Introduction

Brush marker techniques go far beyond just coloring! There are many different blending techniques you can use, such as direct and indirect blending, direct to stamp blending, and resist blending. Learn how to create backgrounds and interesting colorful effects to use in your paper art projects. With the 17 brush marker techniques taught in this book, you can learn something to create any effect you desire. Also included in this book is a special section on DoodleDabs, an easy-to-learn method of drawing beautiful accents using a simple teardrop stroke with a brush marker. Learning the DoodleDab technique will give even those without any artistic training the confidence to draw and add small accents to cards, scrapbook pages, and other paper art projects. You will also find a technique for shading Zentangle®-inspired art pieces with markers.

Brush markers are a well-known implement in the world of rubber-stamping, art journals, and colorful sketching, and have gained loyal users with their brilliant colors and ease of use. I have used Tombow markers exclusively in the book, as they have a long life, are available in a full palette of 96 brilliant colors, and have a strong nylon brush tip that stands up to repeated applications. You can, of course, use other brands of brush markers and find your favorites.

Designed for crafters, rubber-stampers, paper artists, and scrapbookers, this manual of diverse techniques will be your lexicon of ideas for brush markers. So gather up your favorite marker colors and be prepared to wow yourself and others with all of these fantastic techniques!

Contents

About the Author, ii

Supplies, ii

Introduction, 1

GETTING STARTED

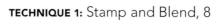

Markers, 3

Other Supplies, 4

Color Blending Basics, 6

BRUSH MARKER TECHNIQUES

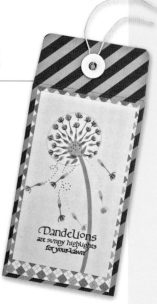

TECHNIQUE 1: Stamp and Blend, 8

TECHNIQUE 2: Direct to Stamp Blending, 10

TECHNIQUE 3: Direct to Paper Blending, 12

TECHNIQUE 4: Direct to Paper Blending with Peel-offs, 14

TECHNIQUE 5: Outline Blending, 16

TECHNIQUE 6: Northwoods Blending, 18

TECHNIQUE 7: Coloring Vellum, 20

TECHNIQUE 8: Indirect Blending, 22

TECHNIQUE 9: Subtractive Stamping on Cardstock, 24

TECHNIQUE 10: Negative Images with Peel-offs, 26

TECHNIQUE 11: Coloring Glittered Peel-offs, 27

TECHNIQUE 12: Glue Pen Resist, 28

TECHNIQUE 13: Splash Backgrounds, 30

TECHNIQUE 14: Fine Tip Lettering, 34

TECHNIQUE 15: Brush Tip Lettering, 35

TECHNIQUE 16: Block Lettering, 36

TECHNIQUE 17: Shading Zentangle® Art, 37

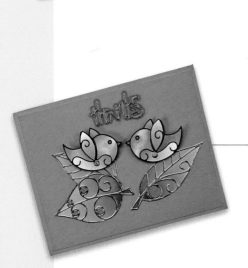

DOODLEDABS

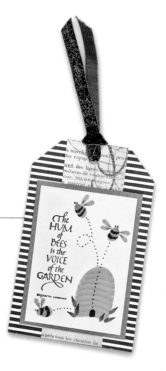

Basic DoodleDabs Strokes, 38

Flower DoodleDabs, 41

Plant DoodleDabs, 46

Critter DoodleDabs, 48

Holiday DoodleDabs, 49

Markers

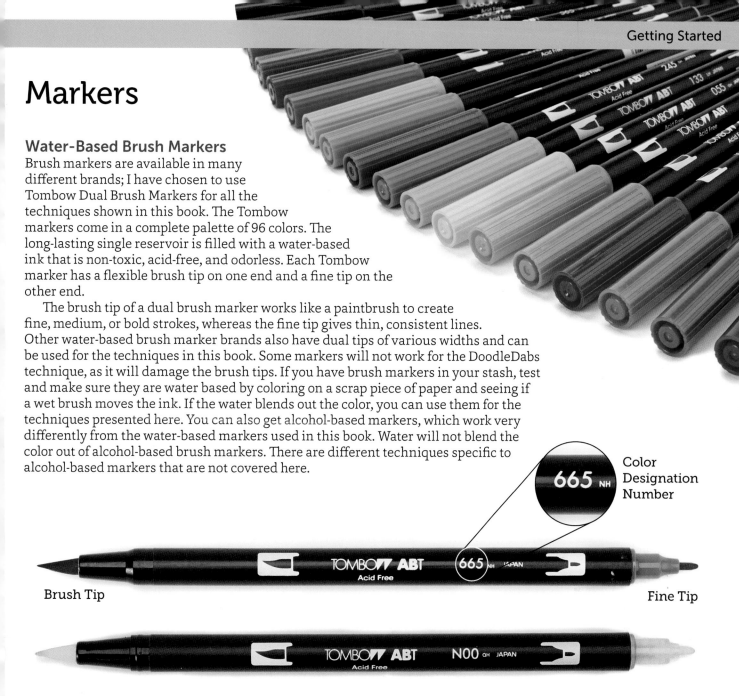

Water-Based Brush Markers

Brush markers are available in many different brands; I have chosen to use Tombow Dual Brush Markers for all the techniques shown in this book. The Tombow markers come in a complete palette of 96 colors. The long-lasting single reservoir is filled with a water-based ink that is non-toxic, acid-free, and odorless. Each Tombow marker has a flexible brush tip on one end and a fine tip on the other end.

The brush tip of a dual brush marker works like a paintbrush to create fine, medium, or bold strokes, whereas the fine tip gives thin, consistent lines. Other water-based brush marker brands also have dual tips of various widths and can be used for the techniques in this book. Some markers will not work for the DoodleDabs technique, as it will damage the brush tips. If you have brush markers in your stash, test and make sure they are water based by coloring on a scrap piece of paper and seeing if a wet brush moves the ink. If the water blends out the color, you can use them for the techniques presented here. You can also get alcohol-based markers, which work very differently from the water-based markers used in this book. Water will not blend the color out of alcohol-based brush markers. There are different techniques specific to alcohol-based markers that are not covered here.

Color Designation Number

Brush Tip

Fine Tip

Colorless Blender

This brush marker softens and blends the colors, creating beautiful effects. It's very handy and is used for many of the techniques presented in this book.

Caring for Markers

Sometimes markers get contaminated with a contrasting color from coloring or brush blending. To clean markers, even if you have a very dark color on a light color, scribble the marker repeatedly on a scrap piece of paper. The nib will clean off and go back to its original color. The colorless blender, shown in the photo, is the only tip that ever stains. Even though there is a color stain on the nib, the ink will continue to come out clear.

Other Supplies

Paper

I use a variety of papers with the techniques in this book. With each technique, I will specify the best type of paper to use. Here are some of the types that you'll definitely want to be familiar with:

- Watercolor paper, 90 lb. to 140 lb. (choose paper with a smooth surface)
- Translucent vellum (choose heavier weight vellum)
- Glossy photo paper (the type used for inkjet printers)
- Colored cardstock (in various colors, including cream and white)
- Patterned cardstock (choose paper that coordinates with your marker colors)

Blending Palette

A blending palette lets you mix colors before applying them to your project. I used the Tombow blending palette, but you can easily create your own. Use a clear sheet of plastic adhered to a piece of white paper. You can make it 4" x 6" (10 x 15cm) or a larger 8 ½" x 11" (21 x 30cm) size. An old CD or plastic container lid will also work as a blending palette.

Water Mister

A small water mister helps you create different effects. Get a mister that will give you a very fine spray. Too hard of a spray will not give you the same results.

Water Brush

A water brush blends out colors. These brushes are designed to hold water in the handle barrel so that you get an even flow as you work. You can also use a small #4 to #6 round paintbrush and container for water together instead of a water brush.

Rubber Stamps

You can buy rubber stamps or digital stamps, or really use any images that you love and already have in your stash. Where applicable, I will talk about the type of stamp that will work best for the different techniques.

Inkpad

I used a black inkpad for most of my images. Check to make sure your inkpad is compatible with the brush markers you will be using. For the subtractive stamping technique, you will also need a light gray inkpad.

Embossing Inkpad and Thermal Embossing Powder

For the Northwoods blending technique, it is best to stamp and emboss the images for best results; use black embossing powder. For the splash background effects, use clear or white embossing powder. To use the powder you'll also need a heat tool; I use the Darice Multi-Purpose Heat Tool.

Peel-offs

Peel-offs are basically outline stickers in metallic or shiny black finishes. I prefer the designs from Elizabeth Craft design because they have large, open areas to color in. They also have a large variety of different images to choose from. If you are a rubber stamper, a stamped and embossed image will also work for some of the techniques.

Paper Trimmer and Scissors

These are needed for trimming your paper and for basic cutting tasks.

Piercer or Fine-Tipped Tweezers

It's handy to have a set of fine-tipped tweezers or a piercing tool when working with peel-offs, as they are tricky to manipulate.

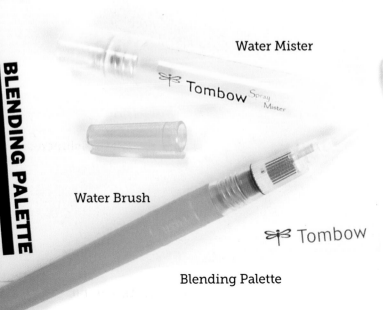

Water Mister

Water Brush

Blending Palette

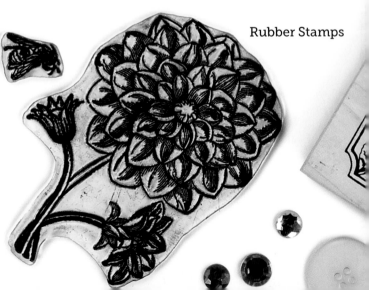

Rubber Stamps

Bone Folder

A bone folder is used for scoring, folding, and smoothing down your paper.

Sand Eraser

For the subtractive stamping technique, you will need a sand eraser. A sand eraser also works great for removing smudges and mistakes.

Glitter

You will need an extra fine clear or white glitter for the glittered peel-off technique. It's also useful as an additional decorative aspect for any project.

Adhesives

I used Aqua and Multi Liquid Glue, various clear tape runners, and dimensional foam tabs for different adhesion tasks. The Glue Pen from Tombow is essential for the resist technique and is also useful for adhering small embellishments.

Embellishments

Dive into your stash to find different small embellishments to help decorate your cards and tags. A general list includes items such as rhinestones, buttons, ribbon, and brads.

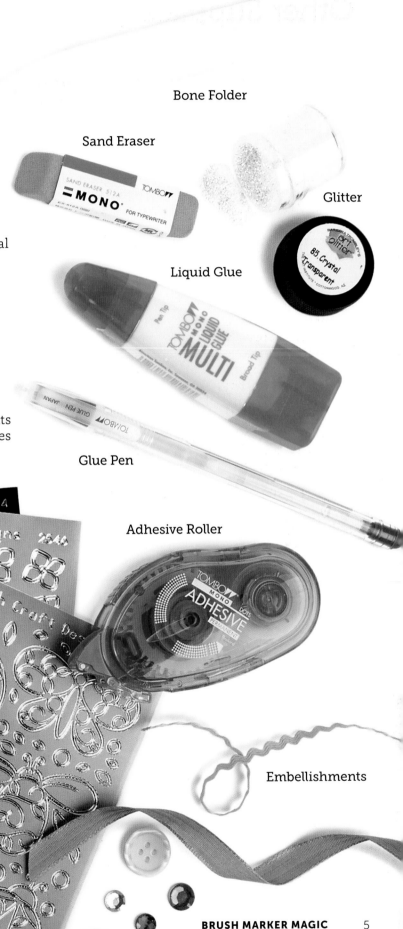

Bone Folder

Sand Eraser

Glitter

Liquid Glue

Glue Pen

Peel-offs

Adhesive Roller

Embellishments

Color Blending Basics

Basic Color Theory

Deciding what colors to use is one thing every project has in common. It is also an area in which many of us have the least amount of confidence. Color surrounds us and plays a major part in our lives; it creates impressions and elicits responses. The average person can see 1 million different colors and the trained eye up to 10 million. Just by working with color, you can start to train your eye to see more colors. Deciding what colors you want out of the millions possible becomes an awesome task. Color theory itself encompasses a multitude of definitions, concepts, and design applications, and fills several encyclopedias! However, everyone can learn the basics about color. The

easiest way to begin is to learn about the color wheel and some general color terms. It's good to know how to "talk color" to give you some idea where to start when blending and adding color to your projects.

Colors can be divided into four groups:

- **Primary Colors:** red, yellow, and blue. These cannot be mixed from other colors. All other colors are derived from these three.
- **Secondary Colors:** orange, green, and purple. The three primary colors are mixed to form this second tier of color. Red and yellow make orange, yellow and blue make green, and blue and red make purple.
- **Tertiary Colors:** mixing one primary and one secondary color makes these colors. Examples include yellow-green, blue-green, and blue-purple.
- **Quadric Colors:** mixing two tertiary colors makes these colors. Examples include russet, cinnamon, citron, olive, forest, and eggplant.

To add further nuance, all colors can then be mixed further:

- **Tinting,** by adding white (with markers, you use water to dilute the color and use the white of the paper to tint)
- **Toning,** by adding gray
- **Shading,** by adding black

Color Mixing Guide

Shown here is a simple color mixing guide that used a primary color brush marker set. You can use this guide to help you see what happens when you mix two basic colors together. Follow the Tombow marker color designation numbers at the top and left sides of the chart to see where they intersect: this is the color they make when mixed together. The last number is water, and shows the colors diluted into tints. When mixing a light color and a dark color together, only a little of the darker color is used relative to the light color; it's not a 50/50 blend.

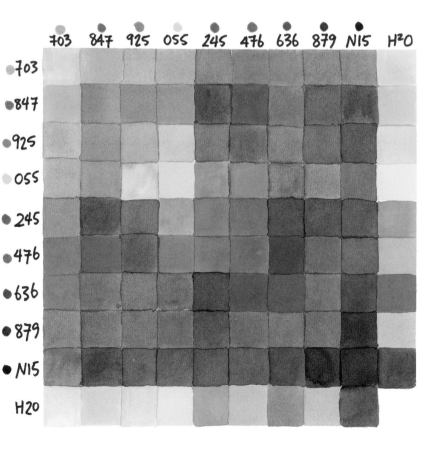

Color Terms

It's good to be familiar with the following basic color terms.

Hue refers to, and is another name for, color. For example, a red-patterned bowl has a red hue.

Chroma refers to the intensity of a color, how bright or dull it is. Scarlet red and brick red are similar in value, but their chroma, their intensity, differs. Brick red is duller, with a lower chroma than scarlet. Scarlet is more brilliant, with a higher chroma than brick red. Colors with low chroma have more of other colors added to them; those with high chroma are more pure.

Value describes the darkness or lightness of a color. A color that is light in value has been diluted with white. For example, pink is a tint of red and has a light value. A dark value color is closer to black on the scale, because it has black added to it. For example, burgundy is a shade of red with a dark value.

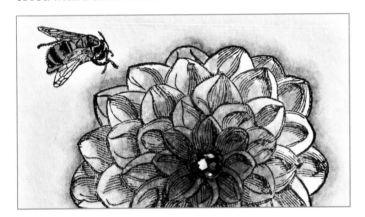

Contrast simply means easily differentiated dark and light shades. Shadowed dark areas will recede and highlighted areas will come forward. In the photo at left, the flower "pops" from the page with a dark center and lighter petals on the edge. The gray halo shading also helps create this effect. You can also color the same flower with a light center and darker petals along the outside for a very different effect that is still high in contrast.

Color Designation Numbers

Each marker has a three-digit number that indicates the hue, chroma, and value of the color. Generally, these numbers are used in science and industry projects or by color separators when color definitions must be described.

The first two digits come from a color palette, and denote the **hue** and **chroma**. For example, 00 to 10 are yellows, 10 to 20 are yellow-greens, 20 to 30 are greens, and so on. The third digit denotes the **value** and is determined on a light to dark scale, with 0 being the lightest and 9 the darkest.

Gray markers are a little different. The designation numbers on the gray markers start with an N, which stands for **neutral**. This is followed by two numbers. The first number is the **value**, dark to light, with 1 being the darkest and 9 being the lightest. The second number is the **temperature** of the gray, from cool to warm, with 1 being the coolest and 9 being the warmest.

A Note about Colors

I will be showing you the basic colors that I used for each technique; in some cases, I will even note the color designation numbers. Please feel free to use your own color combinations! However, you will want to, in most cases, keep the same values. For example, if I used a dark color, a medium color, and a light color, choose your three colors with the same dark, medium, and light values.

You will also want to take color clues from the papers you are using. For example, in the steps for the dandelion DoodleDab at left, I used a pink, gray, and olive green palette. In the dandelion tag sample at right, I used a teal green, warm gray, and dark gray palette, using the background paper as my guide.

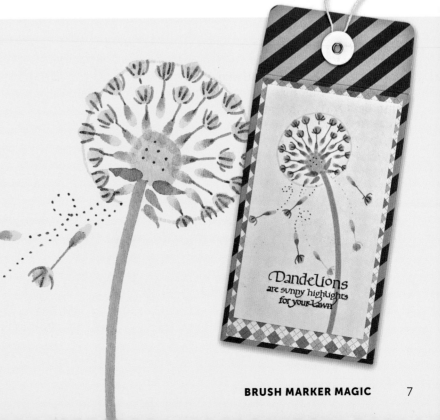

Technique 1:
Stamp and Blend

With this technique, you ink the stamp with the marker's brush tip and blend the stamped image with the colorless blender to create beautiful, soft shaded images.

Materials

- Dual brush markers (443, 452, 725, 947, 245, 761, 062)
- Colorless blender
- Rubber stamp (outline stamps with little to no shading work best)
- Mixed media paper or smooth watercolor paper

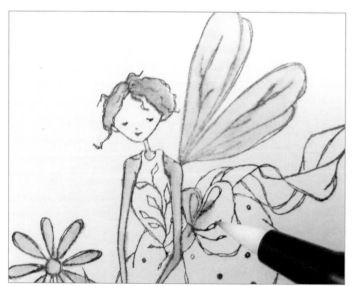

1 Ink the stamp using the brush tips of the markers. Work quickly and don't worry if the colors overlap—it's more important that you have covered all the raised areas on the stamp.

2 Huff (breathe, don't blow) on the colored stamp to introduce moisture and then stamp immediately.

3 With the colorless blender, pull the color from the stamped lines into the open areas, blending the colors as you go. This results in a very soft shaded image.

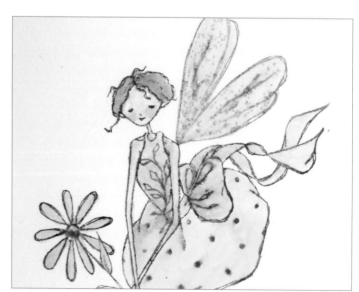

4 When the image is dry, you can add details with the fine tip or embellishments such as rhinestones and glitter.

Tips to Remember

- Use dark colors for best results.
- Make sure to color all the raised areas on the stamp.
- Work quickly and stamp immediately.
- Don't blow on the stamp—that will dry the ink. Instead, huff, like fogging a glass; this will add the moisture back into the ink and allow for a clean stamping.
- Make sure to let the blended colors dry before adding additional details with the fine tip.

TECHNIQUE 2:
Direct to Stamp Blending

Brush markers are great for this technique! Like the stamp and blend technique, you apply the marker ink directly to the stamp. The brush tip lays down brilliant color quickly onto the stamp, and then is misted to introduce moisture before stamping. I prefer red rubber stamps for this technique, but clear cling stamps work as well.

Materials

- Dual brush markers (245, 177, 685, 603, 985)
- Colorless blender
- Water mister
- Rubber stamp (solid stamps with few details work best)
- Mixed media paper or smooth watercolor paper

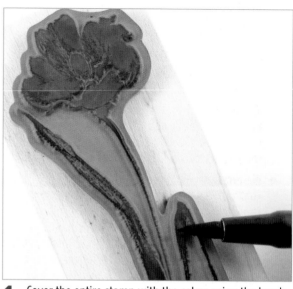

1 Cover the entire stamp with the colors using the brush tips of the markers. To make the image contrast with the background, take a dark color and edge around the stamp's motifs using the brush tip. Blend directly on the stamp with a light color to remove any harsh lines if needed.

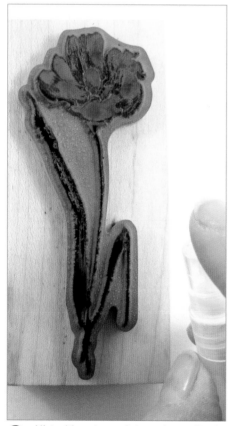

2 Mist with water and stamp immediately.

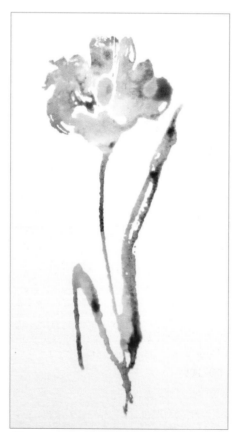

3 This photo shows the freshly stamped image.

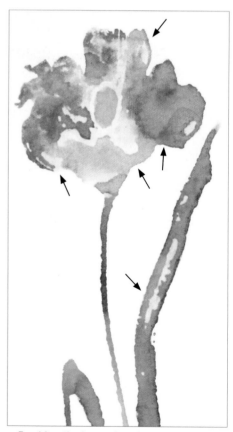

4 After the image has dried, use the colorless blender to blend color into any white patches.

Experiment with Paper

Different papers will yield different results with the direct to stamp blending technique.

- **White cardstock** and **mixed media paper** work well, giving you bright colors, good blending, and sharp images.

- **Watercolor paper** gives you more light and dark color variations and strong blending, but less sharp images. It works really nicely for vintage images and a watercolor painted effect.

- **Glossy photo paper** gives you very sharp images, but not as much blending of the colors. It works best with outline and finely detailed stamps.

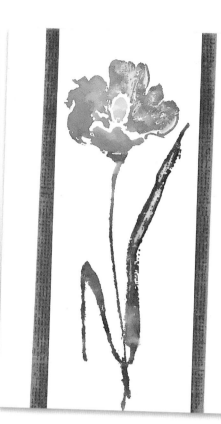

If I had a single flower for every time I think about you, I could walk forever in my garden.

Claudia Ghandi

You are simply ONE of a KIND

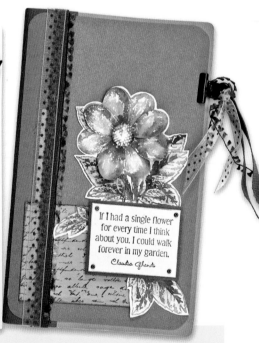

If I had a single flower for every time I think about you, I could walk forever in my garden.
Claudia Ghandi

Tips to Remember

- You can take your time applying the color to the stamp; it will be activated again when it is misted.

- Experiment with the amount of water you spray on your stamp. Too little and the image will not be complete; too much and you will lose details.

- If the color is beading on a clear plastic stamp, gently roughen the stamp surface by rubbing it on a brown paper bag. This very light abrasion will help the stamp hold the color better.

technique 3:
Direct to Paper Blending

With this technique, you apply the color directly to the paper and use a water brush to blend out the colors. The best results come from using a dark, medium, and light hue for each colored section.

Materials

- Dual brush markers (606, 603, 623, N65, N95, 985, 062, 177, 192)
- Water brush, or round brush (sizes #4 to #6) with a container of water
- Rubber stamp (detailed stamps showing shadows work best)
- Smooth watercolor paper

1 Stamp the image with a black inkpad onto smooth watercolor paper. Add color with the brush tip using feathered strokes. Start with the lightest color, using the shading on the stamped image as a guide.

2 Add the medium color, blending it into the lighter color.

3 Add the darkest color. It's okay to leave some spaces white. With florals, add a bit of the flower color, the lightest hue, into the leaves and stems.

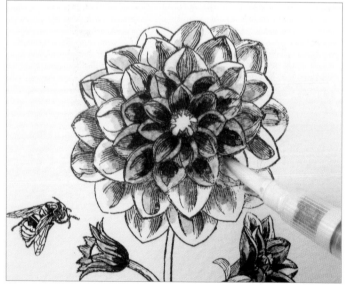

4 Use the water brush to blend the colors for a soft dark-to-light blend. Do not over-blend. You will know if you are over-blending if the paper starts to pill or your colors lose the dark and light contrast. Touch the tip of the brush to a piece of paper towel to remove excess water before blending.

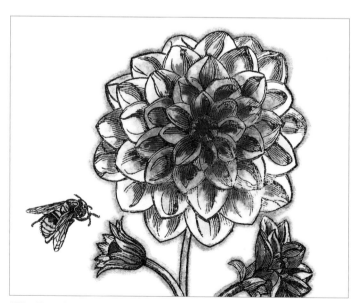

5 For a halo, add the darker halo color around the entire motif. Blend with the lighter halo color. Use the water brush to blend and pull the color out, softening the edges. Wait until the piece is completely dry to evaluate if it needs more color.

Tips to Remember

- Both dark and light colors work with this method—just make sure you have a dark, medium, and light value for each color.

- Use feathered strokes when adding color, making sure they fit into the motif. For example, the strokes added to the flower's petals go in the direction of the blend.

- Work one section at a time.

- Make sure to let the blended colors dry before adding additional colors and blending again.

technique 4:
Direct to Paper Blending with Peel-offs

Peel-offs work great for this technique, as the edges of the motifs act as dams to hold the color in the sections.

Materials

- Dual brush markers (medium and dark values)
- Water brush, or round brush (sizes #4 to #6) with a container of water
- Peel-off sticker
- Piercing tool or fine-tipped tweezers
- Smooth watercolor paper

Tips to Remember

- Add uncolored peel-offs mixed in with colored peel-offs for added interest (see the leaves in the sample on page 15).
- You can use multiple different colors in one motif; you aren't necessarily limited to one color (see the pear in the sample on page 15).
- When cutting out motifs, you can prevent the cut white edge of the paper from showing. Just color the edge of the cutout with the brush tip (see the photo below). It's these little details that make your finished project look professional and carefully created.

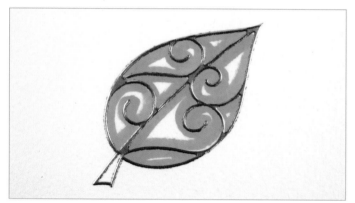

1 Peel-offs are simply outline stickers. (You can also stamp and thermal emboss an image for a similar effect.) Peel and stick the peel-off image to the watercolor paper. I use a piercer to lift and place the sticker; you can also use fine-tipped tweezers. First add the lightest color by outlining each section of the motif.

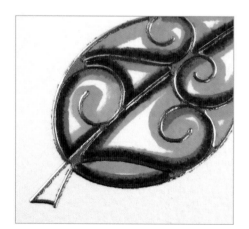

2 Add the medium and dark colors where you want the color to be the most intense.

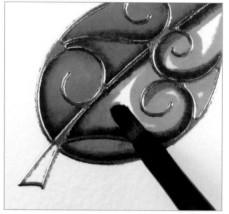

3 Use the water brush to pull and blend the color throughout the motif. The result should be a nice blending from dark to light. Do one section at a time and do not over-blend.

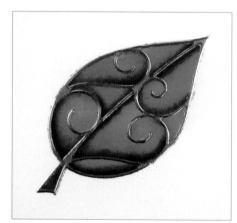

4 The final piece has lovely tones.

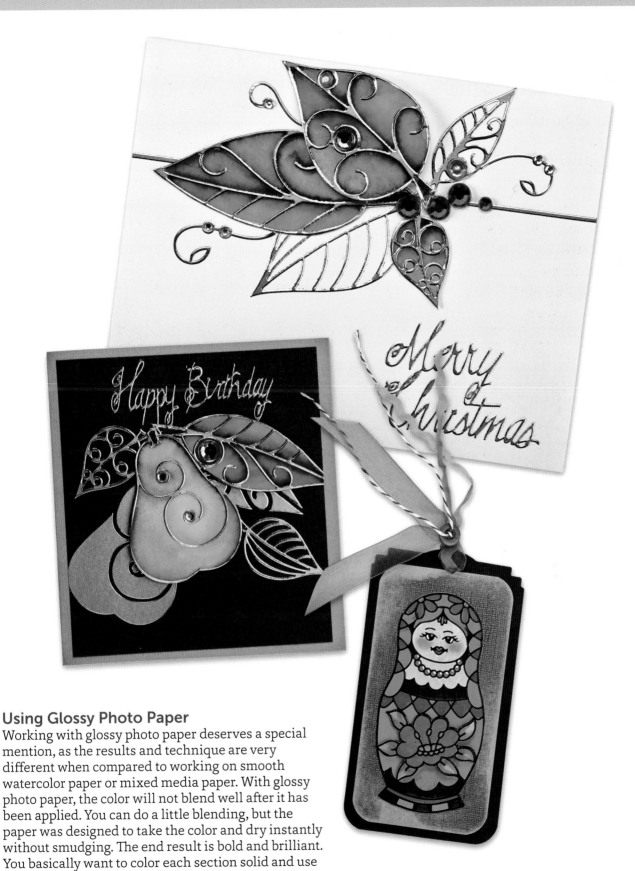

Using Glossy Photo Paper

Working with glossy photo paper deserves a special mention, as the results and technique are very different when compared to working on smooth watercolor paper or mixed media paper. With glossy photo paper, the color will not blend well after it has been applied. You can do a little blending, but the paper was designed to take the color and dry instantly without smudging. The end result is bold and brilliant. You basically want to color each section solid and use lighter colors, because they go onto the paper several shades darker. The nesting doll shown at right was done on glossy photo paper.

Technique 5:
Outline Blending

I love using this blending technique on Zentangle®-inspired artwork. You simply add an outline to the inside of the motif using the brush tip and then blend it using a water brush.

Materials

- Dual brush markers (192, 177, 837, 905, 856)
- Black permanent pen (tested to make sure it does not bleed with the markers)
- Water brush, or round brush (sizes #4 to #6) with a container of water
- Smooth watercolor paper

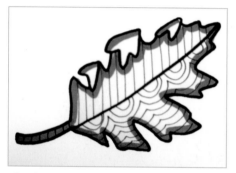

1 Outline along the inner edges of the motif with the brush tip.

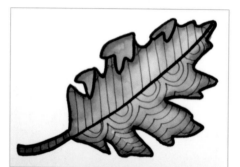

2 Use the water brush to blend the colors for a soft blend. If you are using a brush with water, touch the tip to a piece of paper towel or the back of your hand to remove excess water before blending.

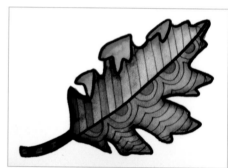

3 Add additional color layers after the first layer has dried. You can use the direct to paper method and blend the color out, or use the indirect blending method (see page 22) by picking up the color from the blending palette.

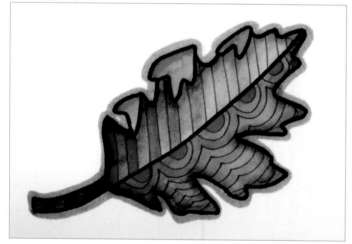

4 With a light colored marker, add a halo around the outside edges of the motif with the brush tip. Here the leaf is shown with a light gray halo. Do not blend this halo out.

Tips to Remember

- Both dark and light colors work with this method.
- Work one section at a time, letting the colors dry before adding color to the neighboring section. This prevents new colors from running into previously colored sections.
- Do not over-blend. Over-blending causes the colors to mix too much, and you lose the dark-to-light effect. It may also cause your paper to pill.
- Use the colorless blender or a water brush to erase any areas where you have gone outside your outline. You can also cover this up with haloing.
- When adding the halo, make sure to go up to the very edge of the motif, without any white space.

"Today is your day, your mountain is waiting. So get on your way."

"Today you are You, that is truer than true. There is no one alive who is Youer than You."

Make a Hanging Decoration

Making the hanging decoration shown at left is easy! Cut out colored flowers and leaves and mount them on black cardstock with jewelry wire sandwiched in between. Then you can hang your new piece of art wherever you like.

technique 6:
Northwoods Blending

The Northwoods blending technique is named after the company that developed it and, coincidently, also makes the best stamps for this method! The method will also work with other stamps.

Materials

- Dual brush markers (025, 277, 673, 685, 443, 800, 443, 451)
- Fine black embossing powder
- Embossing inkpad and heat tool
- Water brush, or round brush (sizes #4 to #6) with a container of water
- Smooth watercolor paper

1 Start with a stamped and embossed image. Cover areas of the image with different base colors applied directly to the paper with the brush tip. This is usually a yellow, but other light colors can also be used as a base. For example, purple is the complement of yellow; if you use a yellow base, the purple will be muddy, so I use a light pink or light blue base instead when working with purple.

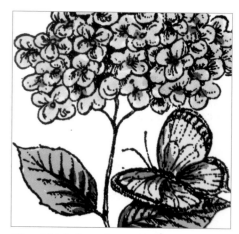

2 Add darker colors to the individual motifs, one section at a time. For intense coloring, apply the darker color to approximately two thirds of the section. Use the shading detail on the stamp for help in deciding where to apply the darker colors.

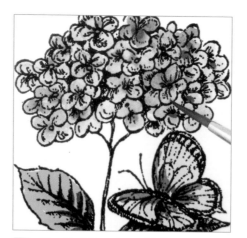

3 Blend out the colors with the water brush. By adding a darker color and blending it out, you will achieve many different shades. Touch the brush to a paper towel to remove excess water—you do not want a puddle.

4 After blending the entire piece, let the colors dry for a few minutes before continuing. Using a light color, add a halo to the image with the brush tip. Blend out the halo with the water brush to soften it. Keep the brush point at a right angle to the stamped image; this prevents you from discoloring your halo with the colors used in the motif.

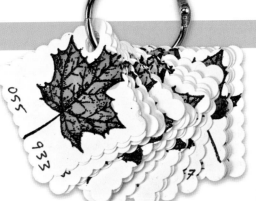

Tips for Combining Colors

I test each color combination before going to my main image. Stamp and emboss a small motif, such as this maple leaf, and test combinations. Then string the successes on a ring so that you have a permanent record of your favorite color combinations. Here are some tips for combining colors.

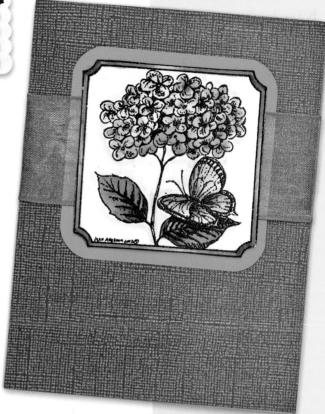

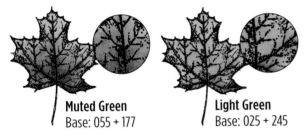

Muted Green
Base: 055 + 177

Light Green
Base: 025 + 245

Here you can see the difference between **blending a lighter or darker color**. You only need to add a small amount of the dark color to achieve a nice gradation of shades. The lighter green leaf uses a brighter, medium hue, so more of the yellow base shows through.

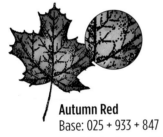

Autumn Red
Base: 025 + 933 + 847

For **three-color blending**, add the base (light) color, then the mid-tone color, and blend. Then you can wait until it is dry or add the darkest color right away.

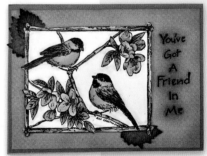

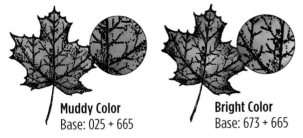

Muddy Color
Base: 025 + 665

Bright Color
Base: 673 + 665

Make sure to **choose the right base colors**. The first leaf was based with yellow, the second with a light purple. Both used a mid-tone purple as the top color and had very different results.

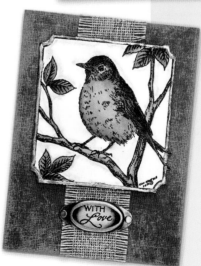

technique 7:
Coloring Vellum

This is a great technique; it's easy and very beautiful and sophisticated. The secret is to always color on the back!

Materials

- Dual brush markers (800, 761, 703, 062, 133, 126, 947, 992, 451)
- Colorless blender
- Rubber stamp (regular stamps with shading details or digital stamp designs)
- Black inkpad
- Vellum (heavier weight parchment type, rather than thin vellum)

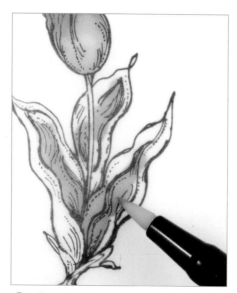

1 Stamp or print out the image on the vellum. This is now the front side of the paper.

2 Turn the piece over—all coloring is done on the back of the stamped piece. Start with the lightest colors, adding them directly to the vellum with the brush tip.

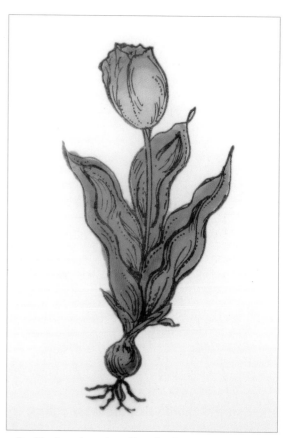

3 Add the medium color and then the darkest color, completely coloring in the sections. Use the shading on the stamped image as a guide to where the darker colors should be. With the slick surface of the vellum, the colors blend nicely together. If you need to refine your blending, use the colorless blender.

4 The translucent quality of vellum further blends your colors together. As you work, take a peek at the front of the image: you will see a big difference! Add a light halo at this stage if you wish.

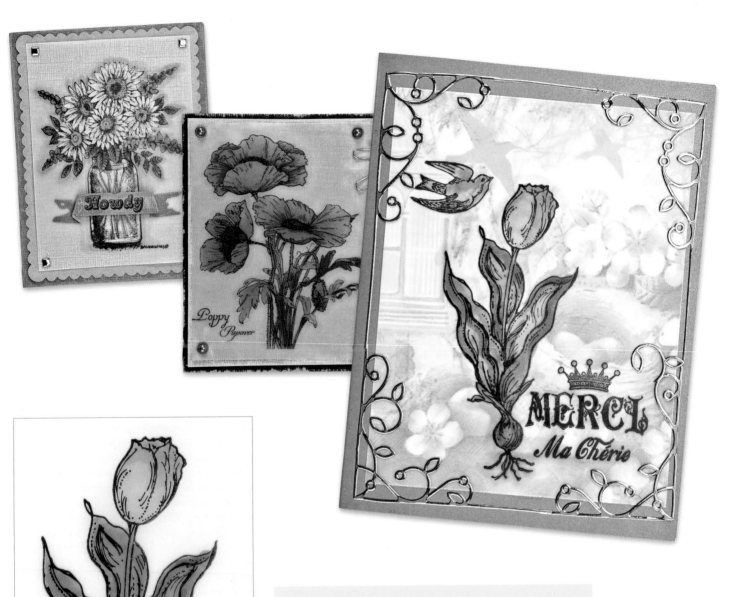

5 Turn the piece over and admire your beautiful blending job!

Tips to Remember

- If you need to blend further, never use water: it will wrinkle the vellum. Use the colorless blender for any additional blending.

- Don't forget what side you are working on. Always color on the back (non-stamped side) of the vellum.

- Don't evaluate your coloring on the back of the image—turn it over to see how the vellum helps to blend the colors.

- Place colored or decorative cardstock underneath the translucent vellum to see what looks best when making your final card or project.

Technique 8:
Indirect Blending

This is my favorite brush marker blending technique. You can use this technique on many different types and weights of paper, and, with practice, you can color faster and more efficiently than with direct to paper blending techniques. The color is placed on a blending palette; you simply pick up the color with the colorless blender and color the image. As you color, it will magically blend from dark to light as the color runs out.

Materials

- Dual brush markers (947, 969, 837, N35; dark colors are best)
- Colorless blender
- Blending palette
- Stamped image or image drawn with permanent ink
- Smooth watercolor paper, mixed media paper, or cardstock (many papers are suitable)

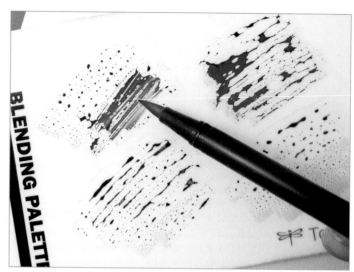

1 Add the colors to the blending palette using the brush tip. They will stay wet on the plastic surface, so make sure not to dip your sleeve or finished piece in the color.

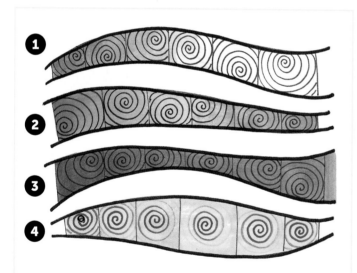

3 For two-color blending, pick up another color from the palette and start at the opposite end of the section. Color the section and blend it into the first color where the colors meet.

Practice Makes Perfect

Practice indirect blending on scraps of paper before starting on your stamped image.

1. Blend out one color with the colorless blender.

2. Blend one color into another color with the colorless blender.

3. Pick up the darker color with a lighter colored marker instead of picking up the darker color with the colorless blender, and then color. The colors will be much more intense.

4. Add patterns with the fine tip.

6 Blend larger sections from the corners, such as the circle background section shown here. To even it out, repeat the blending from the adjacent corner. Keep adding more color to the palette as you go, as it will become lighter as you dilute the color with the colorless blender.

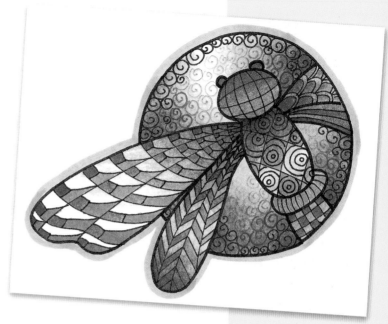

2 Pick up the color with the brush tip of the colorless blender. Start coloring a section of the image where you want the color to be the darkest. Color the whole section. Color back and forth in the shortest dimension within the section—this creates the subtle shading from dark to light as the blender runs out of color. Do not go back into the colored area to fix a mistake or touch up—just make sure you do a neat coloring the first time.

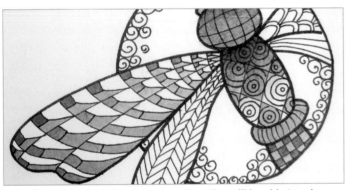

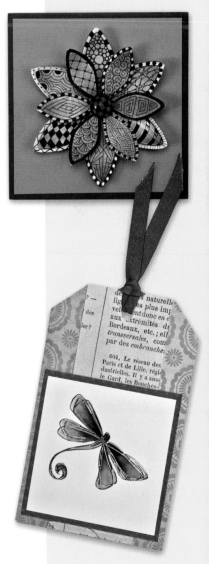

4 Repeat the blending in each section. You will be able to color a whole section if you pick up lots of color from the palette. If your pen runs out of color before you finish a section, you did not pick up enough color; let it dry and then start again at the darkest part. Do not start with a freshly loaded brush tip in the middle of the blend.

5 Layer the blending after you have completed coloring the small sections; this is shown here in the shading on the wing.

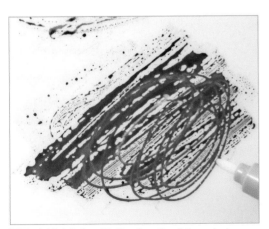

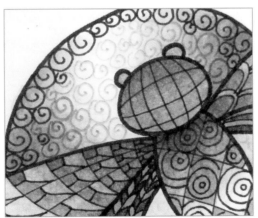

7 Add details with the fine tip of the colorless blender by picking up the color with the fine tip and doing the technique as normal.

8 Here you can see adding a curled pattern. Start where you want it to be the darkest and draw until you have run out of color.

technique 9:
Subtractive Stamping on Cardstock

This is a new technique I developed when I discovered sand erasers. It allows you to stamp and color on decorative cardstock in a unique way: the entire image is surrounded by the background with no cutting out of the stamped image required.

Materials

- Dual brush markers (899, 249, 228, 192, 703, 055, N45, N75)
- Colorless blender
- Sand eraser
- Clear stamp (rubber stamps can also be used)
- Gray inkpad
- Black inkpad
- Decorative cardstock (simply patterned and plain cardstock work best, rather than detailed or multicolored cardstock)*

*For this method, you need cardstock with a white core. Rip a tiny section to make sure the paper has a white core. Most decorative cardstock on the market will have a white core.

1 Cut your paper to size. With the gray inkpad, stamp your image. This image will be very light; you only just need to see the basic image. This gray stamping will disappear in the final image; you are just using it as a general guide for the next step.

2 Using the sand eraser, remove the top layer of printed paper where your image is stamped to reveal the white paper underneath. This doesn't have to be perfect and white to every edge of the image—you just need the general area sanded white.

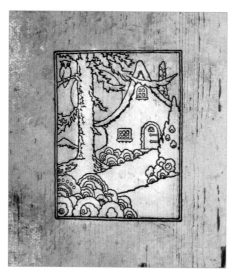

3 Re-stamp your image in black ink. Using clear stamps makes it easy to see the gray stamping and line it up perfectly. Do not worry if you are a little off; the light gray stamping tends to disappear as you add the coloring.

4 Color the image using the indirect blending technique.

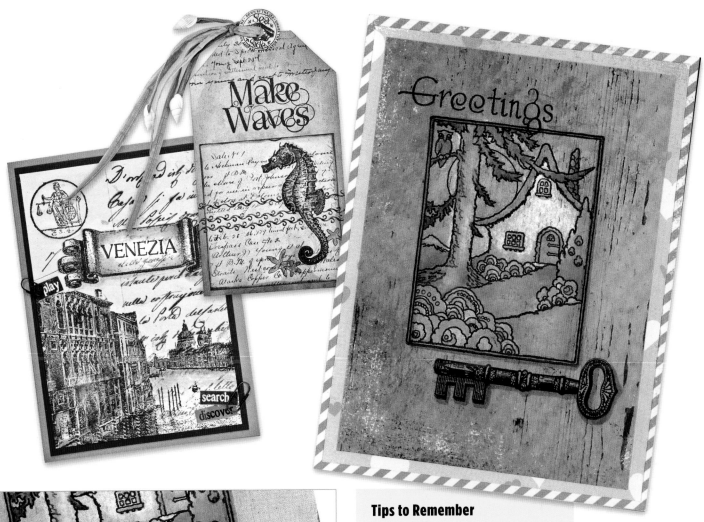

Tips to Remember

- The samples above use a variety of different papers to show the subtractive stamping technique. The cottage is done on a light gray wood paper, the seahorse on a small script paper, and the Venice scene on a vintage imaged paper.

- You'll notice that on the moth card you can still see the faint image of the cardstock design underneath. You can decide on how much of the pattern to remove with the sand eraser. The sanded white underneath, however, will make the marker colors appear cleaner and brighter. For any white details, leave those sections uncolored.

5 Add any additional stamping to the piece as desired. You can also add a halo around the stamped image using a very light gray marker. This helps to illuminate any of the gray stamping and to frame the image.

Technique 10:
Negative Images with Peel-offs

This is a unique technique with peel-offs used as a mask to produce a white-outlined image. The best part is that you can reuse the peel-off for multiple images!

Materials

- Dual brush markers (443, 555, 847, 845, 346, 245)
- Colorless blender
- Peel-offs
- Piercing tool or fine-tipped tweezers
- Mixed media paper or smooth watercolor paper

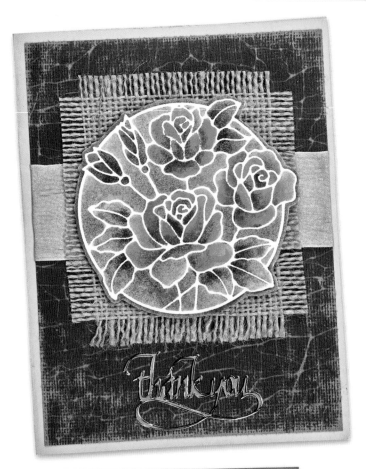

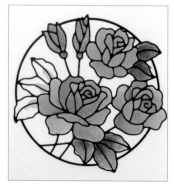

1 Place the peel-off onto the paper. Color the image using the direct to paper or the indirect blending technique.

2 Color around the outside of the peel-off image. This will give the image good definition and leave a white outline.

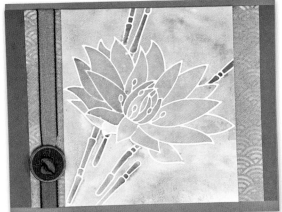

3 Make sure the coloring is bone dry before removing the peel-off. Save it for another negative image by placing it on a non-porous surface, such as a plastic sheet.

4 You are left with a stunning colored image with beautiful white outlining.

TECHNIQUE 11:
Coloring Glittered Peel-offs

A photograph does not do this technique justice! The entire motif sparkles with a gorgeous glittered effect. Try gluing a finished piece to the top of a bamboo skewer to make a cute plant poke as shown right.

Materials

- Dual brush markers (443, 055, 925, 845)
- Blending palette
- Peel-off
- Piercing tool or fine-tipped tweezers
- Bone folder
- White cardstock or mixed media paper
- Double-sided adhesive sheet
- Ultra-fine transparent glitter

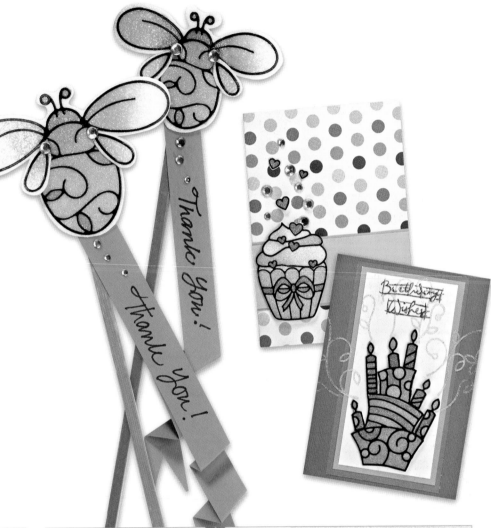

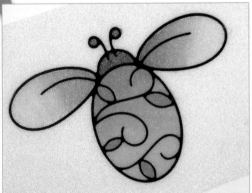

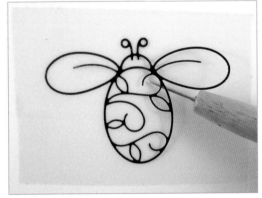

1 Cut a double-sided adhesive sheet slightly larger than the peel-off. Remove the backing paper and place the adhesive onto a piece of white cardstock. Remove the top protective sheet and save it. Carefully place the peel-off onto the sticky surface. Place the saved top sheet overtop of the peel-off and burnish it down. Remove the top sheet.

2 Sprinkle the exposed adhesive with glitter and rub it in with your finger. Remove and reclaim the excess glitter. You can also use a clean, dry brush to remove any excess glitter.

3 Color the glittered peel-off using the direct to paper or indirect blending technique. The marker colors are bright when first applied to the glittered surface, but will dry about two shades lighter as the color seeps into the glitter. The colors take a little longer to dry on the glitter, so be careful about smudging your work.

тechnique 12:
Glue Pen Resist

This technique uses a glue pen to create a resist (where the color will not be absorbed into the paper) and results in white designs within the image. It's perfect for adding polka dots or highlights for additional interest in stamped images.

Materials

- Dual brush markers (925, 725)
- Colorless blender
- Blending palette
- Rubber stamp (outline stamps with little detail work best)
- Black inkpad
- Glue pen (this technique used the Tombow glue pen)
- White cardstock

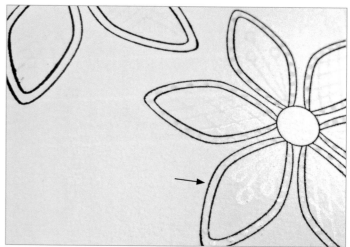

1 Stamp the image onto the paper with the black inkpad. With the glue pen, add dots, lines, patterns, etc., to the image. It can be hard to see the clear glue when you are working. Good overhead light will help, and sometimes you have to hold your head just right to see what you are doing. Let the glue dry completely before proceeding.

2 Using the indirect blending method, color each section of the stamped image, going over the glue marks. The darker the colors you apply, the brighter the resist marks will appear.

3 Use the direct to paper technique to add additional colors in the designs.

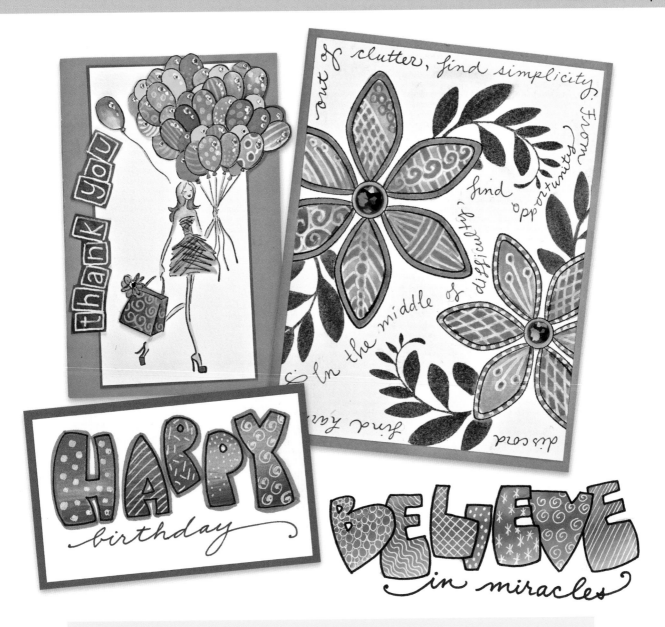

Tips to Remember

- Sometimes, in shipping, the glue pen develops little air bubbles in it that block the flow of the glue. Simply replace the lid and lightly tap the pen on your work surface to get it going again.

- Ignore the glue patterns completely when you are blending using the indirect method—just go right overtop the glue.

- Unlike with masking fluid, you do not have to remove glue resist designs after you add the color when you use a Tombow glue pen.

- This technique works best for line designs, not filled in, solid drawings. For solid masking, use a masking fluid for best results.

- This technique works especially well to create designs within block lettering, as shown above.

- You can also create lightly colored resist designs with this method. With the purse on the card shown above, you can see light yellow swirls on a blue-green background. To achieve this, simply color the purse with a yellow brush marker before adding the glue resist designs. For the balloons on the same card, some balloons were colored yellow first, and in some balloons the resist design was added before any color was added. This gave a nice variety of colors to the balloon bouquet.

Technique 13:
Splash Backgrounds

This is a quick and fabulous way to create an interesting background. If you want to create larger backgrounds, the blending palette must be at least 1" (2.5cm) larger all around than the paper piece you want to use. For example, if you wish to do it on a piece of 12" x 12" (30 x 30cm) cardstock, the palette should be at least 13" x 13" (33 x 33cm). For such large pieces, I simply use the shiny side of freezer paper as the palette.

Materials

- Dual brush markers (different colors with the same value)
- Blending palette
- Water mister
- White cardstock, glossy photo paper, or smooth watercolor paper

1 Using the brush tip, add the marker color to the blending palette. Cover it with solid color. I usually choose darker hues for this technique. However, you can create more subtle backgrounds using lighter colors.

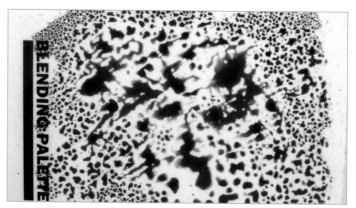

2 Use the water mister to spray the palette with water. Two or three sprays are usually enough. Be careful of what is on your work surface, as the water tends to splash off the palette.

3 Place the paper facedown on top of the palette. Let it soak up the color for a few seconds and then lift it up. This is what my sample looked like when it was fresh and the ink was still wet. Never throw away a background at this point; they change dramatically as they dry.

4 Let the sample dry completely; you can let it dry naturally, or use a heat tool to dry it quickly. If you do not like the image once it has dried, you have options. One option is to just re-do the steps using the same piece of paper and colors; make sure you mist the palette well. Alternatively, you can mist your background with water when it's dry for a mottled effect. A third option is to repeat the steps with new colors on the same paper to create a layered effect.

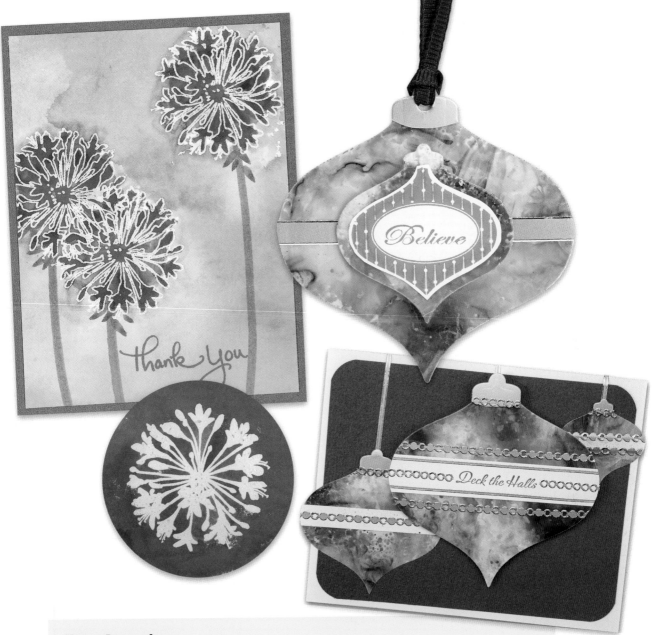

Tips to Remember

- Be sure to sufficiently mist the colors on the palette—spray away to really get it wet.

- After you pick your paper up from the palette, some of the color will run. I generally help it even out by turning and tilting the paper to distribute the colors.

- As I use my blending palette during a session, instead of cleaning it with paper towels, I mist it and create a layered splash background on a piece of glossy photo paper. The ornament card and tag above were die cut from one of these palette cleaning splash backgrounds.

- Stamp an image using an embossing inkpad and then thermal emboss using white or clear embossing powder to get a cool stamped resist splash design like the one at bottom left above.

Salty Splash Background

The salty splash is a simple variation of the splash technique borrowed from watercolorists. Any type of salt can be used, including table salt, coarse salt, sea salt, or margarita salt; they all work and give different results. I used ordinary table salt for the sample shown.

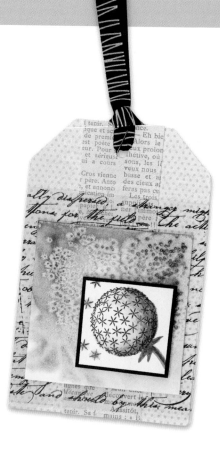

1 Follow the first three steps for the splash background technique. After you lift up the paper, immediately sprinkle it with salt.

2 Let the paper dry naturally. Don't use the heat tool to dry the surface quickly; it just blows away the salt. As it dries, the salt soaks up the color, leaving a very pretty mottled effect. When the paper is dry, brush off the salt.

Cracked Splash Background

Another variation of the splash technique used by watercolorists, this technique uses plastic wrap for a cracked effect.

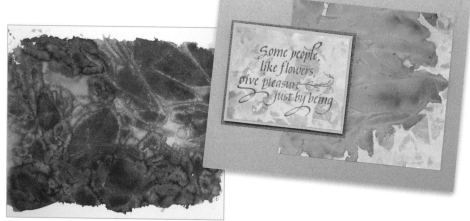

1 Follow the first three steps for the splash background technique. After you lift up the paper, cover the wet surface with a crumpled-up piece of plastic wrap. Gently press the plastic down onto the surface.

2 Let the paper dry naturally. Don't use the heat tool to dry the surface quickly; it will melt the plastic. As it dries, the color settles into the wrinkles for a subtle, cracked effect. When the paper is dry, remove the plastic.

Splashed and Stamped Background

This splash technique variation uses repeated stamp images to create the backgrounds. There are many different variations of this technique that you can experiment with.

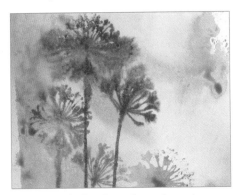

1 Using the brush marker, color a stamp and set it aside. Follow the first three steps for the splash background. After you lift up the paper, stamp immediately onto the wet surface using the pre-colored stamp. You can usually get about three stampings with gradually lighter images. Add more color to the stamp if you want to add more images. Don't overdo it, though.

2 When the image is completely dry, ink the stamp again, huff on it to add moisture, and stamp once more onto the splashed and stamped background.

Marble Splash Background

This splash technique variation creates a marble-like effect. Because real marble has a shiny, smooth surface, this technique is best on glossy photo paper. For this technique, you apply color to the palette in a special way before misting.

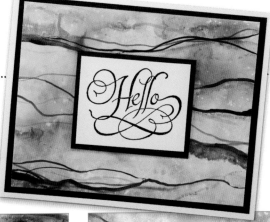

1 Using a light and medium color, add drifts of color to the palette. Along the medium blocks of color, add varied lines made with a dark color. Applying different pressures while you draw the line creates the thin and thick lines. The photo illustrates how color was applied but is shown on paper, not on the palette.

2 Mist the palette, place the paper onto it, and lift the paper up. After you lift the paper up, you can add more thin marble lines with the brush marker. The lines will be faint as you draw on the wet surface.

3 When the image is completely dry, add more veins with the dark marker using a varied line. This creates a dramatic marbled surface. For a softer effect, omit the darker veins and use the medium or light marker to add veins instead.

technique 14:
Fine Tip Lettering

Lettering is something that requires some practice, and you can start here with brush markers. But please do not worry about making your letters perfect—you will develop your own style, so embrace it and enjoy the lettering journey. **A note about spacing:** Beginners struggle with spacing the most. With most lettering styles, it is better to place the letters close together rather than far apart. Sometimes the letters even touch each other or overlap. The spacing between words should be about the width of a small letter o. Keep in mind the most important thing is that the words are readable.

Materials

- Dual brush markers (dark value)
- White cardstock

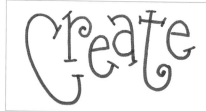

1 **Basic.** At the top of a piece of practice paper, write a word in your neatest printing. Don't make the letters too small; keep the uppercase letters about 1¾" to 1" (2 to 2.5cm) high.

2 **Curl.** Write the word again, and this time try to make the letters a little more interesting, by adding slight curls to the descenders and changing the shapes.

3 **Bounce.** Write the word again, and this time add "bouncing." This means the letters do not all sit on a common writing line, but sit above or below the writing line. Don't bounce too extremely, or the word will be hard to read.

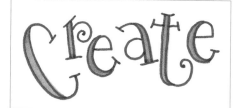

4 **Slope.** Write the word again, and this time bounce and change the slope of the letters. The slope is the degree of slant, either forward or backward from 0 degrees (straight up and down). Mix it up with both forward and backward slopes.

5 **Serif.** Write the word again, and this time add serifs at the ends of each letter. A serif is a small decorative stroke used to finish off the ends of a letter. You can add lines and curls as shown; other simple serifs include dots, thick lines, or double lines.

6 **Weight.** Write the word again, and this time add weight to the letters, thickening the letters. You can just go over the letters to make them bolder, or add weight to specific areas, like lines added and filled with color as shown.

Technique 15:
Brush Tip Lettering

For brush tip lettering, use a heavy pressure to make thicker, bolder letters, and for thinner letters, use a lighter touch. For easy script lettering, use your own handwriting and a varied pressure when creating your letters. For example, start with a heavy, even pressure for each letter, but lighten up and create thinner lines that gradually end in a point. This is what makes beautiful letters: a variation in the line widths. The glorious feature of having both a brush tip and fine tip on the same pen with the same color reservoir is that you can easily correct your lettering and add sharper points and serifs. **A note about letter size:** Generally, letters 1" to 1½" (2.5 to 4cm) tall work nicely when using the brush tip. Any smaller and the letters are harder to make and to read.

Materials
- Dual brush markers
- White cardstock

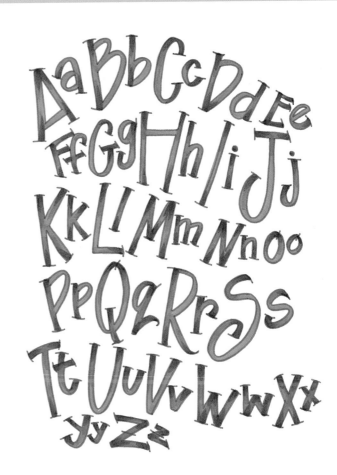

Tri-Color Shading

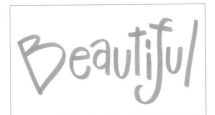

1 Choose three markers of the same hue in a light, medium, and dark value. Write your word with the lightest marker using the brush tip.

2 With the medium marker, trace over the top half of each letter. You may want to use a colorless blender to blend the colors together.

3 With the dark marker, trace over the top half of the medium color. You now have a three-toned colored word.

4 You can leave the letters as is, or outline them and add serifs with the dark marker using the fine tip.

Double Loaded Color

1 Choose two brush markers, a light and a dark. They do not have to be the same color; when mixed, they will create a third color.

2 Add the dark color to the blending palette and then pick up a large amount of the dark color with the lighter marker's brush tip. Always have the darker color on the palette and pick up with the lighter marker. Draw your letters. As you go, the color will change from dark to light.

Technique 16: Block Lettering

You can use the fine tip of a brush marker or a permanent black pen to create block lettering. You can leave the letters plain or fill them in with a pattern. Use a hard lead pencil to sketch the letters before outlining them with the markers. After the colors are dry, you can then erase the pencil lines using a white plastic eraser.

Materials

- Dual brush markers
- White cardstock

1 Start the piece by choosing a saying or word. Sketch out the letters, and then draw in the block letters. Use a light hand with your pencil lines. For colors, choose two dark, a medium, and light color.

2 Outline the letters with the fine tip of the darkest marker.

3 Color the letters by adding the second darkest color to the top third of the letters with the brush tip.

4 Add the medium and light colors to fill up the letters. Blend the colors together using a brush and water to create a smooth, graduated fill.

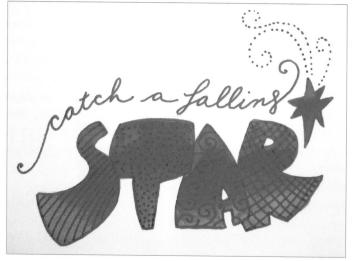

5 With the darkest marker, add a simple pattern in each letter. Add any additional lettering and embellishments you desire. Erase the pencil lines when the piece is completely dry.

technique 17:
Shading Zentangle® Art

I love making my tangles come alive with shades of lights and darks. I also love to shade with brush markers on large ZIAs (Zentangle-Inspired Art). The most important thing to remember when shading is contrast: you want everything from deep darks right up to the clearest whites. When working with small motifs, it's important to keep your highlight areas white, but still have dark shadows to create the shape. And don't make the mistake of shading the whole motif; you need the white to create the illusion of the shape. Follow the tips here to learn about shading Zentangle art, and check out *www.zentangle.com* for more information about Zentangle.

Materials

- Dual brush markers (blacks, cool grays)
- Colorless blender
- Pencil (for drawing strings)
- White gel pen (for adding highlights)
- Black permanent marker
- Mixed media paper

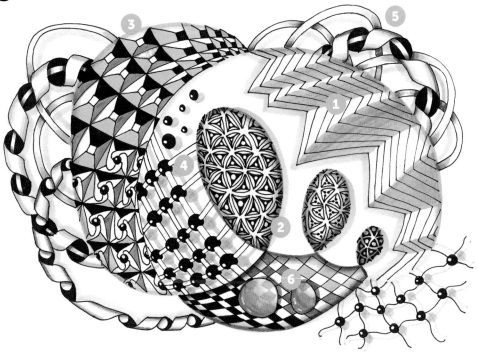

1. Shade solid areas within a tangle. By choosing large areas to shade, you can make the tangle seem to have a physical dimension. (Static, official Zentangle tangle.)

2. Shade around whole tangles at the string. Start with the lightest marker right at the string line, then follow with the next darkest, and finally the next darkest. Keep the point of the marker facing the string; turn the drawing as you work. (Tripoli, official Zentangle tangle.)

3. Shade individual motifs within a tangle for a 3-D effect. Many types of grid tangles change dramatically with the addition of shading. Shade with just one marker. (Cubine, official Zentangle tangle.)

4. Shade areas near a tangle to create a cast shadow effect. Use a light marker, first mirroring the grid lines of the tangle a little ways "below" the inked lines. Add other lines and circles of gray as needed to create the effect of a suspended tangle casting a shadow. (Chemystery, tangle by Maryann Scheblein-Dawson.)

5. Shade to create levels and shapes. Start with a light marker to make a wide shade line right along the edge to which you want to add dimension. Add two thinner shade lines one at a time with darker markers. Make sure to leave some white space as a highlight. (Coil, tangle by Sue Jacob.)

6. Create a gradation with shading. Start with areas of black, then add one or two lines at a time going from your darkest to lightest markers. (Knightsbridge, official Zentangle tangle.)

Basic DoodleDabs Strokes

Quaint, colorful DoodleDabs are created with dual brush markers and feature a simple dabbing technique to create a teardrop-shaped stroke, which is the basis of all the designs. Master this stroke and you will be able to accent cards, scrapbook pages, envelopes, and more with this fun and unintimidating technique! You can create DoodleDabs on any smooth paper; I used a smooth white cardstock for all the samples.

The DoodleDab technique was designed with Tombow Dual Brush Markers. The nylon brush tip is strong and will stand up to the dabbing action, stroke after stroke. The brush tip works like a paintbrush to create fine, medium, and broad strokes. The fine tip provides fine, consistent lines.

Basic Teardrop Stroke

Dab the brush tip onto the paper to make the teardrop stroke. It's that simple! Practice the teardrop stroke on a scrap piece of paper. Apply lighter pressure for smaller strokes and heavier pressure for larger strokes. The teardrop strokes are usually made with the point facing away from you. For example, when making the petals on the daisy, simply rotate the paper to accommodate the stroke.

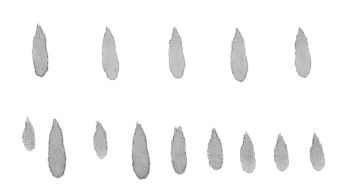

Common mistakes when making the teardrop stroke include the following:

If your teardrop strokes look like this, you aren't pressing hard enough. You will not harm the tip by pressing down on it. You can correct overly small strokes by doing the teardrop stroke again right over top of your first stroke.

If your teardrop strokes look like this, you are dragging the point before lifting up. Slow down—you do not need to speed draw them! If your teardrops are blurry and fat, you are going too slowly and the ink is bleeding, so speed up a bit.

If your teardrop strokes look like this, you are making the stroke more complicated than it is. You are dragging the brush tip down and trying to actually *draw* the teardrop. Just *dab* the brush tip and lift up, and it will automatically make the teardrop shape.

Two-Toned Teardrop Stroke

You will need a blending palette for this technique. To make a two-toned teardrop stroke, choose two colors, one darker than the other. Add a few strokes of the darker color onto the blending palette. Pick up this color with a lighter colored marker by dragging the brush tip through the color. Make the teardrop stroke, and you will have magically created a perfectly blended two-toned mark. You will find you can go far with just one load of color; you do not have to pick up more color for each stroke. When finished, clean the lighter marker by making a few strokes on a piece of scrap paper until the darker color is gone and the pen is back to its original color.

Constant Lines and Dots

These marks are created with the fine tip. Remember to turn the marker around and use this point whenever you need a fine line, such as a stem for a flower, details in oval strokes, or a dotted flight path for a butterfly. For larger dots with highlights, draw a tiny circle, draw the open circle for the highlight, and fill it in with color. You can also make two-toned lines with the fine tip; it's the same technique as a two-toned teardrop stroke, but with the fine tip.

Other Basic Strokes

Here are a few other strokes to create the different DoodleDabs and to accent the basic teardrop strokes. Take a few moments to practice all the strokes, experimenting with different pressures and color combinations. Your strokes may vary slightly from the ones illustrated here, but not to worry: that will just give the DoodleDabs your own distinctive look.

Cone stroke: Place the brush tip onto the paper horizontally and make the teardrop stroke while flicking the pen downwards to create the cone shape. Move the paper to change the direction of this stroke. This shape makes the top of the daffodil or can be used to make butterfly wings.

Oval stroke: Place the brush tip onto the paper and make a tiny circle while applying pressure on the tip (top row). This creates the oval shape and, when you have two colors on the marker, creates a beautiful two-toned oval. If you are getting an open circle in the oval, you are not pressing down firmly enough. If you are getting a point at the top of the finished oval, you are not shaping a complete circle. If you find this stroke hard to master, simply draw a small oval and color it in, then add a line of another color to create a two-toned look (bottom row). This makes a small oval that can become a rose blossom or a bumblebee.

Long stroke: Drag the brush point down to make this stroke. Apply different pressures to determine the thickness of the stroke. If you lift the marker off the paper with a flick, you will create a point on the top, as with the daffodil leaves. One example of what this stroke can make is bamboo.

Varied stroke: Vary the thickness of this stroke by applying light pressure for a thin mark and heavier pressure for a thick mark. You can make this stroke slowly, but do not hesitate in the middle of the stroke. Practice making this stroke with points at both ends. Tulip leaves are a good example of this stroke.

DoodleDabs Step-by-Steps and Samples

On the following pages, you'll see a host of ideas for DoodleDabs, each shown in an easy-to-follow step-by-step progression. You'll also see some real samples of how you can use DoodleDabs to jazz up cards and gifts! Whether you're interested in Flowers, Plants, Critters, or Holiday DoodleDabs, you're sure to find some fun inspiration here. The colors I have used in the samples are just suggestions; be creative by making your DoodleDabs in a variety of hues! Experiment and enjoy. What new DoodleDabs can you create?

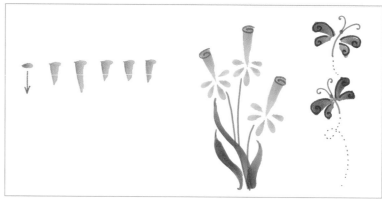

Cone Stroke

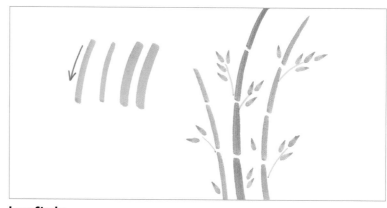

Oval Stroke

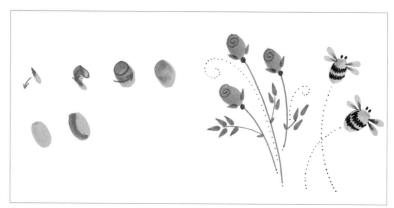

Long Stroke

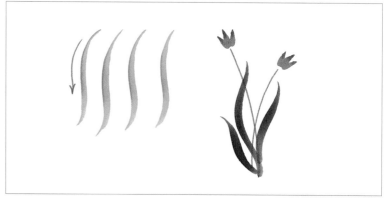

Varied Stroke

Flower DoodleDabs

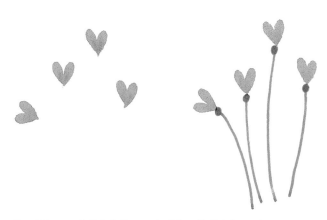

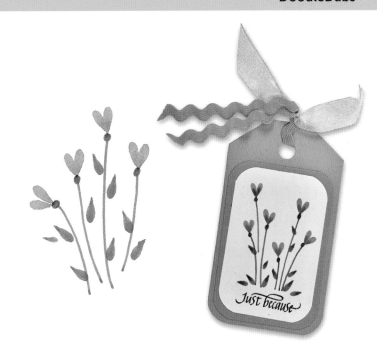

Heart Bouquet: This is the easiest DoodleDab to make: just two teardrop strokes with the points together!

Heart Bluebell: By changing the colors and adding a drooping stem, you can create bluebells with heart blossoms.

Heart Vine: Hearts turn into flowers when placed along a vine. Add the hearts along the line first, without touching it.

Flower DoodleDabs (continued)

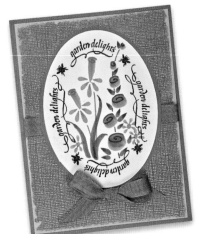

Daffodil: Be sure not to place the trumpet strokes too close together, or you will not have enough room for the petals.

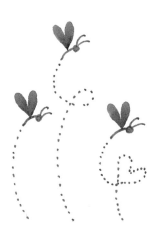

Love Bug: The heart shape can make cute bugs as well as flowers. See more critter ideas on page 48.

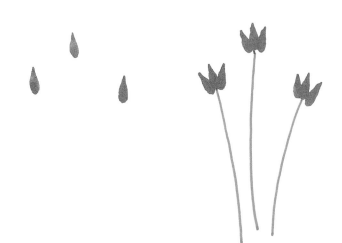

Tulip: Create the blossom with a cluster of three teardrop strokes with the points facing upward.

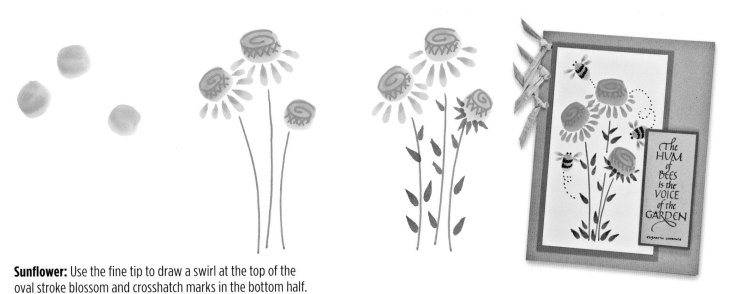

Sunflower: Use the fine tip to draw a swirl at the top of the oval stroke blossom and crosshatch marks in the bottom half.

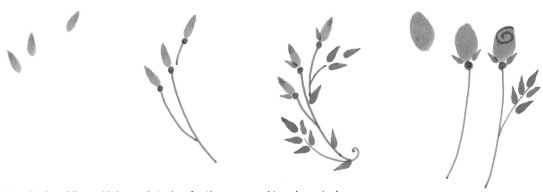

Rosebud and Rose: Make oval strokes for the roses and teardrop strokes for the rosebuds. Using the fine tip, add a dot at the base of each blossom.

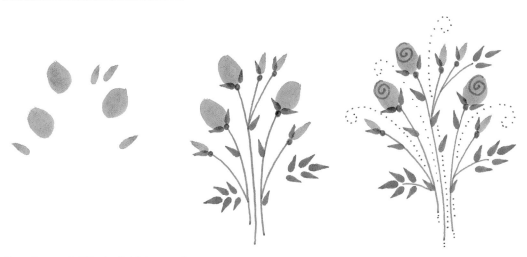

Rose Bouquet: I like to finish bouquets with dotted lines with curls on the ends.

Flower DoodleDabs (continued)

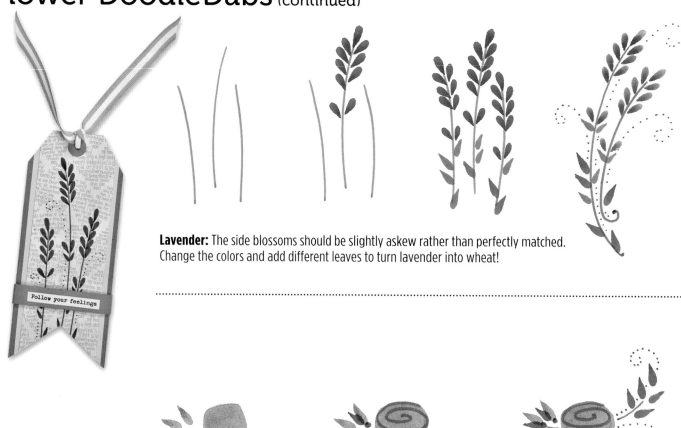

Lavender: The side blossoms should be slightly askew rather than perfectly matched. Change the colors and add different leaves to turn lavender into wheat!

Large Rose: Start the large rose with a large, fat oval stroke. Smaller teardrop strokes make the rosebuds.

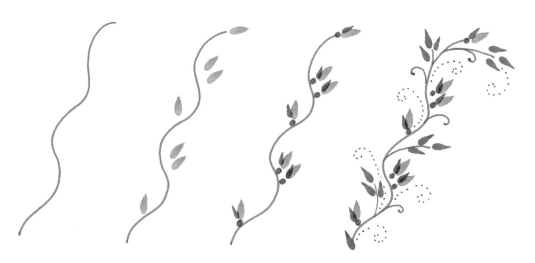

Rosebud Vine: Create a rosebud vine by drawing the vine first and then adding the rosebuds, leaves, and small curls.

Hollyhock: Add a swirl in each blossom with the fine tip.

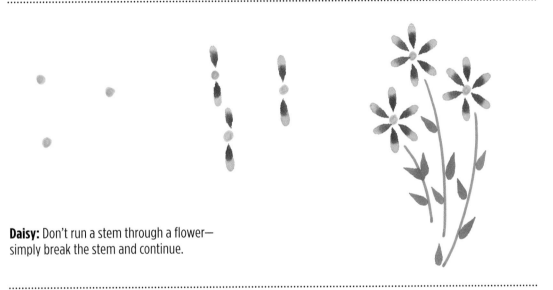

Daisy: Don't run a stem through a flower—
simply break the stem and continue.

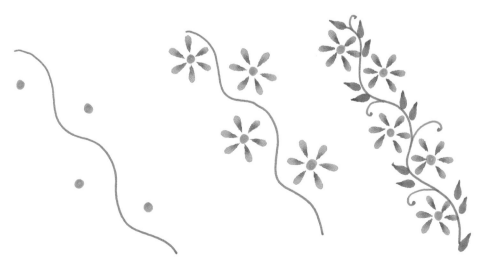

Daisy Vine: Create the curved vine and then add the flower centers. Make sure
your daisy centers are far enough away so the petals do not overlap the vine.

Plant DoodleDabs

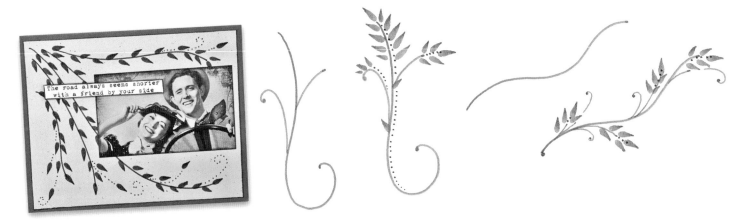

Fern and Vine: Try adding dotted spores along the stems on the ferns.

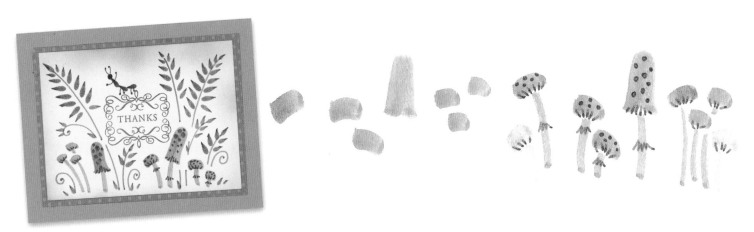

Mushroom: The caps of the mushrooms are made with short strokes using the brush tip. Add the stems with the brush tip using long strokes.

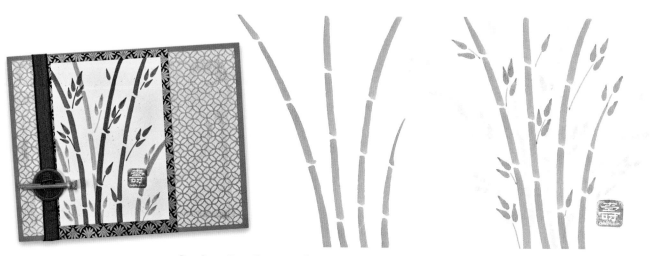

Bamboo: Keep the spaces between the strokes small, or it will look like dashes rather than bamboo.

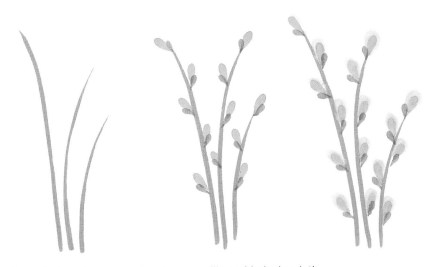

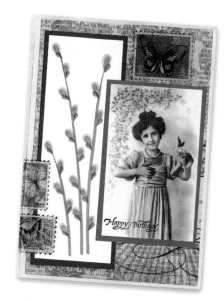

Pussy Willow: Draw around each pussy willow with the brush tip using a very light color to make them appear soft.

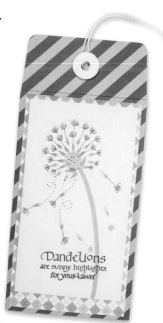

Dandelion: The individual "wishes" are made with a large dot and a teardrop stroke. Draw a line with the fine tip to join them, and add tiny lines for the fluff.

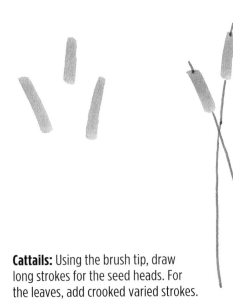

Cattails: Using the brush tip, draw long strokes for the seed heads. For the leaves, add crooked varied strokes.

Critter DoodleDabs

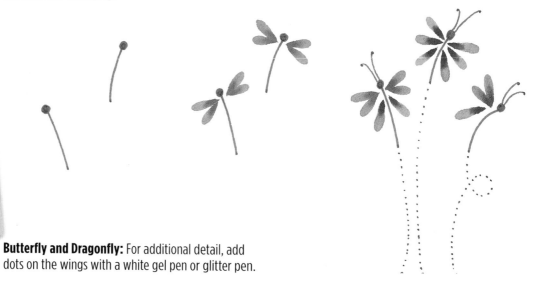

Butterfly and Dragonfly: For additional detail, add dots on the wings with a white gel pen or glitter pen.

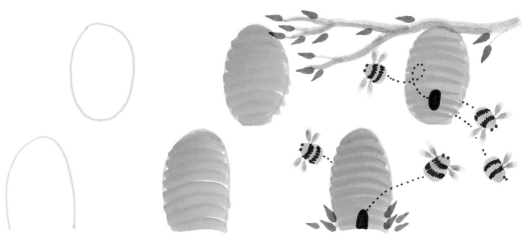

Beehive: Blend a light and darker color together and color in the hive using slightly curved long strokes starting from the top. Use the fine tip to make the eyes, stripes, and dotted flight path of the bee.

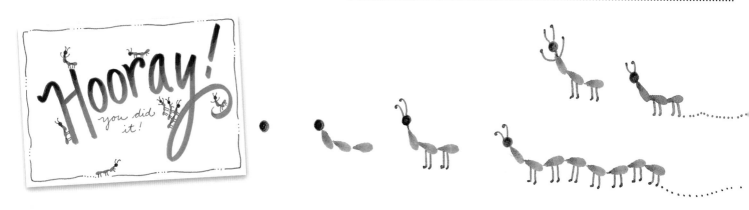

Ant and Centipede: Add more than three body segments to create a centipede!